Eight Artists The Anxious Edge

Jonathan Borofsky

Bruce Charlesworth

Chris Burden

Robert Longo

David Salle

Italo Scanga

Cindy Sherman

Hollis Sigler

Walker Art Center

25 April – 13 June 1982

Acknowledgments

On behalf of the Board of Directors and staff of Walker Art Center, I would like to thank the eight artists represented in this exhibition for their cooperation. Through all phases of this project they have been helpful and responsive; they submitted to lengthy interviews and made key examples of their work available for showing. I am also grateful to the many individuals, galleries and museums who generously loaned their valued paintings, drawings, sculptures and photographs to this presentation. Finally, special thanks are due those Art Center staff members who worked on various aspects of this exhibition.

Eight Artists: The Anxious Edge continues the museum's *Viewpoints* program, a series of exhibitions documenting significant developments in contemporary art. The *Viewpoints* program is supported by the National Endowment for the Arts and the Dayton Hudson Foundation; additional support for this exhibition is provided by the General Mills Foundation.

Lisa Lyons
Curator, Walker Art Center

Unless otherwise indicated, dimensions in the checklist are in inches; height precedes width precedes depth.

Lenders to the Exhibition

Bo Alveryd
Kalinge, Sweden

Mary Boone/Leo Castelli
New York, New York

Rena Bransten
San Francisco, California

John Breitweiser
Chicago, Illinois

Barbara Brooker
San Francisco, California

Phoebe Chason
Harrison, New York

Paula Cooper Gallery
New York, New York

Mr. and Mrs. Charles M. Diker
New York, New York

Mary Donovan
San Francisco, California

Ronald Feldman Fine Arts, Inc.
New York, New York

Rosamund Felsen Gallery
New York, New York

Barbara Gladstone Gallery
New York, New York

Wally Goodman
San Francisco, California

Richard Grossman
Minneapolis, Minnesota

Nancy Hagin
New York, New York

Mr. and Mrs. James Harithas
New York, New York

Doris and Robert Hillman
New York, New York

Barry Lowen
Los Angeles, California

Metro Pictures
New York, New York

Museum of Contemporary Art
Chicago, Illinois

Paine Webber, Inc.
New York, New York

RoseWeb Projects
New York, New York

Doris and Charles Saatchi
London, England

Herbert and Lee Schorr
Briarcliff Manor, New York

Mr. and Mrs. Eugene M. Schwartz
New York, New York

Lynn and Jeffrey Slutsky
New York

Daniel Weinberg Gallery
San Francisco, California

Five Private Collections

The Anxious Edge

Lisa Lyons

As we move into the 1980s, our ability to form an optimistic world view is increasingly undermined by the grim realities of daily life. A stagnating economy, widespread crime and unemployment, all contribute to an atmosphere of growing pessimism and uncertainty. This psychological malaise is fueled, the historian Christopher Lasch observes, by still other "storm warnings, portents, hints of catastrophe."[1] The threat of nuclear annihilation and well-founded predictions of ecological disaster on a global scale have engendered anxieties in many individuals about the state of the world and its future.[2]

A relationship between social and aesthetic developments is inevitable and on numerous occasions throughout history the emotional tenor of an age has reverberated in the arts. Why should the present be an exception? Certainly, we can discern direct reflections of current attitudes and concerns in popular culture, and perhaps no more clearly than in punk and new wave music. Its sonic and lyric assaults are permeated with a negativism that seems more hostile than youth's perennial rejection of established values. Similarly, a nihilistic spirit informs Beth and Scott B's roughly edited Super-8 movies, which are inhabited by a host of neurotic characters who offer caustic meditations on such grim topics as urban terrorism. In a more aestheticized vein, JoAnne Akalaitis's experimental theater production, *Dead End Kids: A History of Nuclear Power,* focuses, as its title suggests, on a subject that has been too often studiously avoided in the arts.

Against this background, we can consider the work of the eight artists in this exhibition. They are by no means members of a single coherent movement and their art encompasses a wide range of media—painting, drawing, sculpture, photography, video and combinations of these. In fact, their styles and methods are so diverse one could reasonably ask what unites these works. The answer: a common spirit of restless, nervous intensity reflecting the artists' reactions to the volatile mood of our times. Though fixated on present realities, theirs is less an art of overt social protest, than an art of disturbing images embodying the tensions and danger just below the surface of everyday life. If all this sounds bleak, take heart, for as we shall see, some of these artists express in their works a great deal of wit and humor, albeit usually of the "black" variety. A certain Duchampian quality, a whiff of that Dada master's ironic sensibility, can be detected in many of their creations.

The attitudes of many of these artists were shaped in the 1960s and 1970s, two decades characterized by radically different social and aesthetic impulses. If the 60s were synonymous with turbulent social change and open-ended invention in the visual arts, manifested in a startling parade of "isms," then the 70s were a time of consolidation, contraction and introspection—qualities reflected in the self-analytical character of new painting and sculpture and in an avid new interest in historicism. Not surprisingly, the effects of the philosophical and stylistic contradictions of those decades are evident in many works in this exhibition.

Unless otherwise noted, all artists' quotes are from tape-recorded interviews with the author.

1. Christopher Lasch, *The Culture of Narcissism,* New York: W.W. Norton and Co., Inc., 1978, p 3.

2. See Peter Schjeldahl, "The Hydrogen Jukebox: Terror, Narcissism and Art," *LAICA Journal,* October-November 1978, pp 44-46, for a provocative discussion of the "long-term toxic effect of the atom bomb terror" on the arts.

Nowhere is this peculiar confluence and incongruity of style and attitude more apparent than in the art of Jonathan Borofsky. Although his work over the past 15 years has been marked by numerous stylistic shifts, it remains primarily conceptual: it is as much about the process of creation as it is about the individual objects he makes.[3]

In the late 60s, after completing his academic art training, Borofsky decided that "painting and object-making were dead" and he stopped making "things" altogether.[4] "I started thinking a lot," he says, "Duchamp to Pollock, Pollock to whom, to what?" For the better part of the year, he sat in the studio, "writing thoughts down for hours at a time—notations and diagrams about the universe and about time." After a year or so of that "heavy thinking routine," Borofsky found himself writing numbers 1, 2, 3 . . . 1, 2, 3 . . . 1, 2, 3 . . . repetitively on sheets of paper for an hour or more. Eventually, he decided to count consecutively "from one to whatever" and write the numbers on sheets of 8½ x 11 inch paper, thinking that if he kept at it for a while, the process might teach him something. Still counting in 1973—by now the stack of papers measured 3½ feet high and contained more than 1,000,000 numbers—Borofsky found he had been making little scribbles on the numbered pages—stick figures, heads in trees and other cryptic forms—which initially he ignored. "Then one day," as he explains it, "I looked at one of the scribbles and thought, I'd like to make a painting of that. So I went out and got a little canvas board and some oil paints—like I was eight years old again and beginning my first painting lesson. It took me about two hours to finish it . . . I took the number I had been counting and put it in the corner of the painting. Something connected there. I had both a recognizable image and a conceptual ordering in time. I realized I could continue the counting and yet bring back my image-making which I had dropped in the late 60s." Thus began a long series of paintings, each rendered on commercial canvas board in a naive, even childlike style. Indeed, the first works in the series were based on childhood memories but later, fueled by his group analysis sessions, Borofsky began using his dreams as points of departure, writing them down on paper in the morning, later transferring them to canvas boards or stretched canvas. In 1974, he began painting dream images directly on the wall, eventually developing the technique of enlarging them to gigantic proportions with the aid of an opaque projector.

3. Joan Simon, "An Interview with Jonathan Borofsky," *Art in America,* November 1981, p 157.

4. *Ibid.*, p 158. (Note: all quotes by Borofsky derive from this source.)

Jonathan Borofsky
I Dreamed the Trees Behind My Parents' House Were Either Trimmed Bare or Removed at 2,170,250 1973
I Dreamed I Saw Buddy Rifkin . . . at 2,198,637 1973
(Borofsky checklist nos 3, 6)

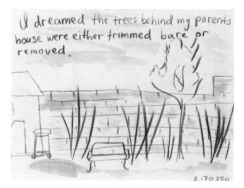
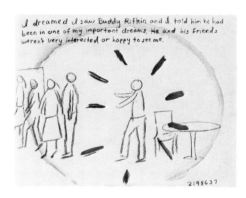

Since then, Borofsky has continued to work environmentally and he has made individual objects in various media. Viewers entering his Art Center installation will be bombarded with an overload of images derived from his dreams, doodles and photographs culled from books, magazines and newspapers. Each of the works, which range from diminutive ink sketches to expansive paintings and monumental sculptures, is numbered, providing a constant reminder that beneath the exuberant expressionistic facade of Borofsky's art is a highly methodical base.[5]

Perusing the myriad images that span the past ten years of Borofsky's production we find certain recurring themes, the most persistent of which is "the fear of being chased." This archetypal dread first appears as the subject of a 1972-73 work, *Dream #1 at 1,944,832,* a 30-foot long, six-panel painting. In words and images it relates Borofsky's dream about himself as a child with his mother in which they are attacked by a youth gang in a strange city. Tall, ominous buildings rendered in broad strokes of black and gray paint recall the hallucinatory sets of such early 20th-century German expressionist films as *The Cabinet of Dr. Caligari.* The chase theme reoccurs in *Running Man at 2,550,116,* the colossal self-portrait sculpture that dominates the installation. Magnified as in a dream, the painted wood cut-out is a powerful image of the psyche under stress. "It's me I guess," Borofsky notes, "but it's also humanity. He's looking back with a certain anxiety . . . Looking over my shoulder to see who's chasing me—a person, my past, Hitler, whatever."

Commenting on Borofsky's use of free association and dreams as catalysts for his work, several critics have suggested a kinship between his art and that of the surrealists. Unlike the surrealists, however, who used dreams to probe the mysteries of the unconscious, Borofsky uses dreams to clarify the meaning of ordinary experiences. If there is anything truly hallucinatory about this artist's work, it is, as Joan Simon has noted, " . . . the structure of an entire installation. As with our own dreams, we can be inside a Borofsky installation, actually surrounded by it, and at the same time feel like outsiders looking in, scrutinizing the parts in detail."[6]

In contrast to Borofsky, who continually journeys through the vaporous world of the psyche, Robert Longo casts a cynical eye on the real world as exemplified by the modern American city and its inhabitants. Initially, his lacquered, cast-aluminum reliefs and monumental graphite and charcoal drawings appear to be the essence of objective observation. Yet, these imposing images are charged with an impatient, nervous energy, a restlessness at odds with their precise execution. Longo's metropolis is an ominous environment. Its multi-story buildings loom and jut at odd angles, while its citizens are caught freeze-frame fashion in ambiguous contorted postures: they could be dancers moving to the rhythm of rock music or victims of an anonymous assassin.

Longo belongs to that generation of young artists for whom the mass media are a powerful source of inspiration. Until recently film stills and magazine ads served as points of departure for his work. The fighting pilots in one of his reliefs, for example, are based on a *New York Times* ad for the film, *1941;* similarly, the men locked in combat in another relief, *The Swing,* derive from a scene in the Sam Fuller film, *Pickup on South Street.* Longo no longer uses media images as source material. "I just can't wait for

5. *Ibid.,* p 157.

6. *Ibid.*

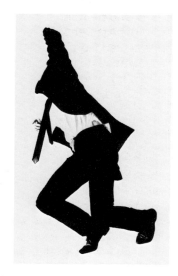

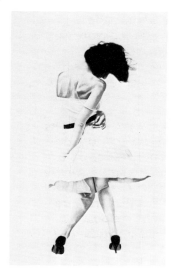

Robert Longo
Untitled (Men in the Cities) 1981
Untitled (Men in the Cities) 1981
(Longo checklist nos 6, 7)

something to crop up," he explains. Instead, he takes countless photographs of friends posing on Manhattan rooftops, and like a film director, carefully sets up the scenes. He has choreographed a subject by suggesting, for example, that he pretend he has just been shot in the shoulder. Some, whom Longo has used as models for several years, easily assume the contorted poses he prefers. Less seasoned performers, however, may find themselves the victims of good natured assault by "rocks or balls—anything that's handy"—anything to get the right stance. From three rolls of film, he usually gets two or three slides that are suitable for works.

Back in the studio, Longo projects the images onto paper and traces the figures in graphite, stripping away all details of the background. After he records the basic contours, a professional illustrator, Diane Shea, continues work on the figure for about a week, filling in the details. Next, Longo goes back into the drawing, using a combination of graphite and charcoal, to provide, as he says, "all the cosmetic work." At this point, he makes a number of changes in the figure. Some are subtle: just a little more definition to a shoulder, perhaps, or a darker cast to the shoes. Others are radical: a subject, who in the original photo was wearing jeans, may finally sport a pair of formal black trousers in the drawing. Longo continues to work on the drawing making numerous adjustments until, about a week later, it is completed.

The process of making a relief is equally involved. Studio assistants do much of the basic work on a piece which is eventually turned over to a foundry where it is cast and lacquered. Though his use of assistants has on occasion been controversial, the practice has several precedents, from the old masters with their workshop minions to the minimalists whose creations involve the talents of industrial fabricators.

The subjects depicted in Longo's finished drawings and reliefs usually bear little resemblance to their photo portraits. Through his graphic and sculptural transformations, they become anonymous and depersonalized. As he puts it, "When I draw pictures of people, I am not *drawing* them— I am *neutralizing* them. I want them to be everybody. Not so much a master race, but archetypes." The figures in a recent relief triptych, for example, are so "customized" that, though they are based on photos of three different people, they seem to be simply the same person viewed from three different angles. Set side by side in serial arrangement, they resemble the leaping figures in Muybridge's chronophotographs and evoke a similar cinematic sense of movement through time and space.

Formally and conceptually, Longo's highly edited, depersonalized views of the real world stand in sharp contrast to Borofsky's work which is the essence of improvisation and psychic exploration. Indeed, their creations occupy opposite ends of a spectrum whose poles can be described as inner and outer reality. Between them we can locate the work of each of the other artists in the exhibition.

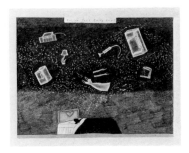

Hollis Sigler
But She Can't Really Forget 1981
(Sigler checklist no 7)

Hollis Sigler's art, like Borofsky's, is essentially autobiographical and narrative. And like him, she employs a naive, even childlike style, though she had years of academic training. As a student, she became increasingly disturbed by the "impersonality and overly intellectual qualities" of the photo-realist paintings she was making. "I really had a romance with paint," she says, "but I realized that there was a disconnection between myself and my work in an emotional sense . . . I was anxiety-ridden by the whole situation. I was stuck. But eventually I remembered that as a child I never had any problems drawing. So I tried to work as I had then . . . drawing without skill, without perspective, without proportion, without passing judgment . . . I tried to deal with my interior space, to describe in images how I felt at the moment, rather than deal with things outside myself."

Since that time she has focused on the creation of narrative drawings and paintings loosely based on events in her life. Sigler describes them as different episodes in the life of a fictional character she refers to only as "the lady" or "she." The most recent episode takes the form of an environmental installation titled *A Journey to Somewhere from Nowhere.*

Its centerpiece is a series of nine drawings that chronicle the woman's futile attempts to escape her oppressive existence in a suburban tract house. With nervous lines and staccato strokes of brilliant color, Sigler describes its interior, a magical place where, through the artist's inventive transformations, mundane objects become lively animated presences, each with a will of its own. The story begins as the heroine, symbolized by a chair, tries to escape the stifling constraints of domestic life by tunneling out of her kitchen, only to find herself trapped in the basement. Next, she makes a rash attempt to rid herself of her demons—her household appliances—by tossing them onto a raging bonfire in her living room. But these acts of destruction do not succeed and soon her dreams are haunted by the ghostly apparitions of the appliances that hover above her bed as she sleeps. The story comes to a climax in the eighth drawing, *She Had to Confess It was Me,* in which the woman is put on trial for her actions. The flat, hierarchical composition of this drawing is based on that of early Renaissance Last Judgment scenes, while its glowing jewel-like colors are reminiscent of the palette employed by the northern Italian master, Simone Martini, whose work Sigler greatly admires. Here the woman, again represented by a chair, stands at center stage on a pedestal under the harsh glare of an interrogation lamp. To either side are the witnesses—her battered appliances. Directly above are the judges, represented by a row of six chairs while below the extended hands of "the damned" threaten to pull her down into their hellish realm. Having confessed her guilt, the woman is mercifully acquitted and in the last drawing in the sequence, "she," now depicted by a lounge chair, rests in her front yard. A bikini lying on the ground, Sigler says, symbolizes the woman's shame at exposing herself, in her weaknesses and frailities, for all the world to see.

Three oil paintings depicting the woman's dreams and her fantasies of romance and glamour elevate the mood of the story. The subject of the largest of these, *She Wants to Belong to the Sky, Again,* was inspired, Sigler says, by childhood dreams of flight, while its palette and style reflect her ongoing admiration of the light-suffused paintings of Claude Monet. Here the woman, now symbolized by a crimson gown, flies away from a family picnic and soars up into a dappled, rainbow-hued, impressionistic sky.

Sigler describes the objects in the installation as mementos of the woman's journey. Superficially they resemble the tacky items sold in a resort curio shop, but these are hardly ordinary souvenirs. Postcards and wooden plaques depict the objects "she" destroyed, and plastic ashtrays, decorated with thick blotches of lurid dayglo paint and glitter, bristle with clumps of fake fur.

On one level, *A Journey to Somewhere from Nowhere* may be viewed as the diary of the archetypal mad housewife who is, ironically, enslaved by all the conveniences intended to make her life easier.[7] But the story has deeper significance for the artist who acknowledges that "she" is her alter ego. As Sigler explains it, the *Journey* reflects her recent thoughts about abandoning the repertoire of symbols and the formal conventions she has developed in her work over the past few years. Hence, her decision to illuminate the symbols in the drawings and to have "the lady" attempt to destroy them.

———

Sigler's view of art as an arena for exploring personal and cultural myths is one shared by several artists in the exhibition. Prominent among them is Italo Scanga who, though he left his birthplace in Lago, Calabria, some 35 years ago, carries with him many aspects of his Italian heritage. His southern California studio is festooned with peasant artifacts, ceramic ware and icons, and visitors there are more often than not treated to impromptu feasts of rough sausage, cheeses and, of course, bread and wine. Particular qualities of Scanga's Italian background also resonate in his sculptures, many of which incorporate images of saints, primitive farm tools, hollow gourds and glass vessels that evoke the religious and secular rituals of rural peasant life.

Scanga approaches his art, as he does his food and friends, with gusto. His ribald spirit infects even a recent series of sculptures whose subject—fear— is hardly humorous. Some sculptures embody personal fears of the elemental forces of nature: fire, darkness and lightning. Others represent the mundane, but no less prepossessing, cultural fears of marriage and success.

Built in a style that has been characterized as "folk constructivism,"[8] these exuberant anthropomorphic assemblages are composed of rough-hewn planks, twigs and branches and such found objects as bottles, corks, tops and canes. The parts are held within an armature of twisted metal struts and expressionistic blotches of thick paint animate their surfaces with luminous color. Like Renaissance sculptures of the saints, the figures display their symbolic attributes. Firmly rooted in a chunky wooden cross, *Fear of Drinking* thrusts a wine bottle over his head. Flames leap from the arms and lick at the feet of *Fear of Fire,* a spindly figure poised atop a skeletal platform resembling an ironing board. A pair of pink ballet slippers, a gift from the artist Eleanor Antin, droops from the hands of *Fear of the Arts.* This wistful figure is Scanga at his best. Its sinuous, curving body provides a dramatic counterpoint to the severe geometry of its minimalistic base.

Scanga draws on a variety of sources for the subjects of his sculptures. For instance, an article in *Psychology Today* about the latest fear to take hold of the contemporary imagination, fear of success, inspired the sculpture of the same name. *Fear of Buying a House* came about, Scanga explains,

7. Allan Schwartzman, *A Journey from Somewhere to Nowhere,* Tampa: University of South Florida Art Galleries, 1982.

8. Christopher Knight, "Italo Scanga," *Artforum,* November 1970, p 94.

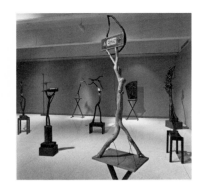

Italo Scanga
Installation at Walker Art Center

because " . . . when you pick up the newspaper in California, all you read about is real estate. Nobody talks about anything but real estate here." No doubt, living in California also had something to do with his piece, *Fear of Earthquakes.*

Stylistically, Scanga's works refer to a wide range of traditions from the distant and recent past. Precedents for much of his imagery can be found in the revolutionary forms of early 20th-century Russian Constructivism. *Fear of War,* a striding, funnel-helmeted stick figure brandishing a wooden rifle, for example, is based on El Lissitzky's soldiers built from the letters K and R in his 1928 designs for a children's arithmetic book, *The Four Mathematical Progressions.*[9] Scanga also draws freely on the pictorial vocabulary of the naive folk sculptures he so passionately collects. Indeed, in their simple method of construction and broadly painted, elemental wooden forms, his figures resemble backyard whirligigs and primitive toys.

The practice of borrowing from art historical and popular culture sources is one of the strongest links between the artists represented in this exhibition. Mining the bottomless image bank of modern culture, they breathe new life into old traditions and provide inventive solutions to formal and expressive problems that have always occupied artists. This freewheeling approach to art-making is nowhere more evident than in David Salle's paintings that combine images, techniques and formal devices from virtually every register of the stylistic scale. Salle took painting lessons throughout his childhood in Wichita, Kansas. In the early 70s, as a student at Cal Arts, however, he became a conceptual artist, making videotapes and photo pieces. Moving to New York in 1975, he gradually worked his way back to painting via linoleum block prints and drawings on canvas.[10] Much of their iconography—"soft-core" nudes, airplanes, car crashes—derived from "B" movie stills that Salle "collected" from the photo files of a magazine publishing house where he worked part time.

Today Salle continues to use found images for his paintings, appropriating them from an ever-increasing number of sources including newspapers, magazines, comic books, reproductions of American social-realist paintings of the 1930s, and how-to-draw manuals. In some paintings, such as the diptych *My Subjectivity,* Salle juxtaposes two distinct styles. Its left-hand panel is a minimalistic, black masonite rectangle whose surface has been drilled with a uniform grid pattern of circles. The adjacent panel contains a grisaille nude kneeling on a chair. Rendered in a dry illustrational style, her shadowy form emerges mirage-like from a green field.

In other works, among them *A Long Life,* Salle sets adrift numerous dissonant images against flatly painted fields. This horizontal composition is bracketed by fragments of two life-class-style figures: a raised arm with a clenched fist and the lower torso of a standing figure seen from the back. At the center, a schematic floorplan of a building is superimposed over a comic book scene of two bodies being hurled into space out of the vortex of an explosion, which at close range atomizes into a pattern of abstract marks. Though placed with care to achieve a delicate compositional equilibrium, the disparate images clash aggressively and their apparently arbitrary juxtaposition is nerve-racking. As we contemplate these nudes, these anatomical renderings, these characters who seem to have leapt onto

9. *Ibid.*

10. Peter Schjeldahl, "David Salle's Objects of Disaffection," *The Village Voice,* March 23, 1982, p 83.

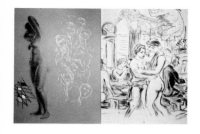

David Salle
A Couple of Centuries 1982
(Salle checklist no 7)

the canvas from the pages of *Death Comix*, their possible significance multiplies, yet nothing really adds up and we are left with a sense of disorientation.[11]

Floating as if in various layers of time and space, the images in Salle's paintings continually elude interpretation. They are " . . . held in a nexus of won'ts and can'ts," he says, "like something always held away from you, successively distanced. . . ."[12] Rendered dispassionately and divorced from expected associative contexts, familiar images and scenes become remote symbols of a world where everything is ultimately arbitrary and meaningless. "The paintings are dead," Salle has written.[13] Indeed, they evoke an unnerving sense of suspended animation in the viewer and, if only for a moment, they seem to stop time.

Such psychological relationships between viewer and image are equally important to a discussion of Chris Burden's art. Although he produces works in a variety of media, he is essentially a conceptual artist who describes his work in coolly philosophical terms as " . . . an examination of reality. By setting up aberrant situations," he says, "my art functions on a higher reality, in a different state."[14]

In the early 1970s Burden rapidly achieved recognition with a series of memorable performances that tested his physical and psychological endurance. In *White Light/White Heat,* for example, he spent 22 days lying on a shelf constructed high in the corner of an otherwise empty gallery. During the entire piece, he did not eat, talk or come down from his perch. Though he could not see or be seen by gallery visitors, his presence could be felt; a palpable sense of energy emanated from the platform and activated the entire room.

Burden feels that his performances have been largely misunderstood and he flatly denies any wish to harm himself. In fact, the performances were structured like psychological experiments with a specific set of controls and with certain physical and emotional obstacles to be confronted. In each case the odds of the presented dangers becoming actual were very slim. In a way, then, witnessing a Burden performance was very much like watching a skilled aerialist who works without a net. Hanging over each performance was the question: "What if . . . ?"

Evoking the unexpected and demonstrating various states of energy, the persistent themes of Burden's performances, also are at the heart of his work in this exhibition, *The Big Wheel.*[15] This monumental, kinetic sculpture consists of an 8-foot diameter, 4,000 pound, cast-iron flywheel and a 250 cc motorcycle mounted on a wooden trestle base. Backed against the wheel and accelerated through all its gears to a top speed of 70 miles per hour, the motorcycle drives the wheel into a frenzied spin that lasts for up to two hours after the cycle has been turned off.

The piece has two distinct lives: as a performance and as an object.[16] First, we witness the driver starting up the bike; his small figure looks vulnerable next to the immense weight so close behind him. The thunder of the accelerating motor audibly intensifies the sense of power and energy projected by the cast-iron giant.

11. Carter Ratcliff, "An Attack on Painting," *Saturday Review,* January 1982, p 51.

12. David Salle, "Images that Understand Us: A Conversation with David Salle and James Welling," *Journal,* June-July 1980, p 44.

13. David Salle, "The Paintings are Dead," *Cover,* May 1979.

14. Jan Butterfield and Chris Burden, "Chris Burden: Through the Night Softly," *Arts Magazine,* March 1975, p 68.

15. Fred Hoffman, "Chris Burden's Humanism," *Artweek,* October 27, 1979, p 1.

16. *Ibid.*

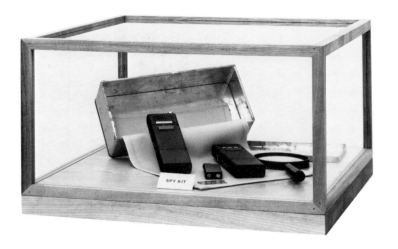

Chris Burden
Spy Kit 1979
(Burden checklist no 15)

Once the cycle is disengaged, a gentle wind flows off the wheel into the surrounding space. As we stand back and watch, the endlessly spinning wheel assumes hypnotic force, becoming a mesmerizing object of quiet contemplation. Yet at the same time, the wheel looms above us as an "infernal machine," its power unchecked by any human control. Ceaselessly working but generating nothing, it is an absurd symbol of our society's continual squandering of energy.

An element of caustic social commentary also informs Burden's *Devil Drawings* and *Sculptures* which resemble documents and relics of past performances. Recalling Duchampian readymades, the *Sculptures* consist of objects housed in glass cases. For some, such as *Radio Sculpture,* which resembles the top of a teenager's bedroom dresser with its piles of coins, toys, beer cans and postcards, Burden simply isolated objects in his studio and placed them in cases. For others he assembled a dangerous looking collection of found and altered-found objects. The most compelling of these, *Case of Street Weapons,* presents an inventory of common objects transformed into the lethal arsenal of an urban survivalist: a spiky club fashioned from a wooden stick; an automobile antenna; a homemade blow gun; and a whip at the end of which a razor blade protrudes from a piece of a rusty sardine can.

Resembling the tattered pages of a scrapbook, the *Devil Drawings* are large collages containing newspaper clippings, personal memorabilia and handwritten notations. *Creatures Beyond Fathom of Science,* for example, combines a glossy photo of a missile-launching warplane; a newspaper report of the mysterious disappearance of four planes in a "baby Bermuda triangle," and a dried "snakehead skin scrap from a snakeskin shirt that I made for my first wife that she never wore." Another presents a *Herald Examiner* headline screaming, "Strangler Hunt Grows," a photo of an F-14 bomber and a picture postcard of the California coastline with an arrow pointing to Venice captioned, "I live here." The *Devil Drawings* embody, Burden explains, "the relationship between my personal panic and insanity and society's." The feeling of menacing violence these works graphically evoke serves as a reminder that the grim realities of life we would rather forget deserve our attention.

12

Like Burden, Bruce Charlesworth uses personal experiences and current events as points of departure for his works. Since the mid-1970s when he abandoned painting to seek new formal and psychological possibilities in technology, he has produced, directed and starred in an ongoing series of narrative films, "photo plays" and videotapes whose plots and ambience are reminiscent of Hollywood *films noirs* of the late 1940s. Like those crime melodramas, Charlesworth's stories are populated by a host of hapless anti-heroes who stumble through life in sinister urban night worlds where surveillance, frame-ups and imprisonment are standard fare.

For this exhibition Charlesworth has produced an environmental installation titled *Projectile.* A maze of dimly-lit rooms resembling domestic interiors, it is the setting for a videotaped "detective story" about the events leading up to the disastrous impact of an unidentified flying object. This end-of-the-line narrative was inspired, Charlesworth says, by memories of a recent event—his house was hit by a tornado last spring—and by thoughts about a possible future event—nuclear war. Its protagonist, played by the artist himself, is a crime suspect named Johnson who is being trailed by a gumshoe detective. Through an almost accidental decision to impersonate an absent character, Johnson makes his way to the space represented by the installation—the home of a militant survivalist. There he has a long conversation with the survivalist's new girlfriend in the cinder block comfort of the basement bomb shelter when, suddenly, the mysterious projectile hits the house.

Within the installation the narrative is pushed into three dimensions. The rooms resemble the setting of the tape and contain some of the props used in the production. There is a gaping hole in the ceiling and debris from the projectile—various mechanical parts, wires, metal sheathing, propellers, plastic fins, rubber hoses and broken glass—is scattered across the floor. As we wander through the spaces and ponder, as Johnson does in the tape, what could have hit the house with such force, we become not merely witnesses to but participants in the curious events taking place on the screen.

Bruce Charlesworth
Three video images from *Projectile* 1982
(Charlesworth checklist no 1)

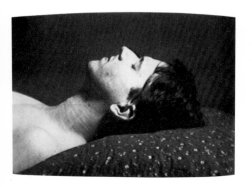 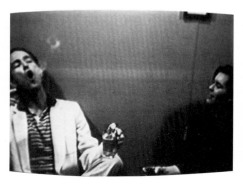 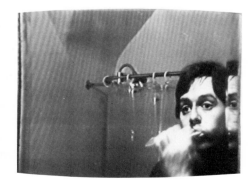

Charlesworth brings to his work an acute understanding of the aesthetics of cinema. His virtuoso framing of shots and careful editing of scenes, elegantly intercut with musical interludes and title cards that propel the action, reveal his training as a filmmaker. Discussing his work, Charlesworth cites Buster Keaton as an important influence on his acting, writing and directing. In fact, like "the great stone face," he is an excellent actor with a strong visual presence, fluid movements and expressive eyes. Furthermore, Charlesworth has a well-developed sense of irony and he exploits, as did Keaton, the potential humor that lies just beneath the surface of the most grim situations in his tapes. Indeed, the plot of *Projectile,* like many Keaton films, moves through the nebulous territory between melodrama and farce.

The concept of performance, so crucial to Charlesworth's work, is also at the center of Cindy Sherman's art. The photographs she has produced since 1977 are essentially narrative tableaux in which the artist herself is the sole protagonist. Unlike other artists who produce self-portraits, however, Sherman does not attempt self-revelation in her pictures; instead, bewigged, costumed and made-up, she evokes before the camera a series of dramatic personae, each with its own aura, its own particular presence.[17]

Sherman never had any formal training in filmmaking or acting, but from watching movies and studying Hollywood film stills and pictures in fan magazines she has developed an uncanny understanding of the aesthetics of cinema. An early series of black and white photographs is essentially one-frame movies in which Sherman plays a variety of cliché female roles derived from 1950s Hollywood and European films: the career girl, the busty blonde starlet, the small town girl lost in the jungle of the big city.

17. Andy Grundberg, "Cindy Sherman: A Playful and Political Postmodernist," *The New York Times,* November 22, 1981, p 35.

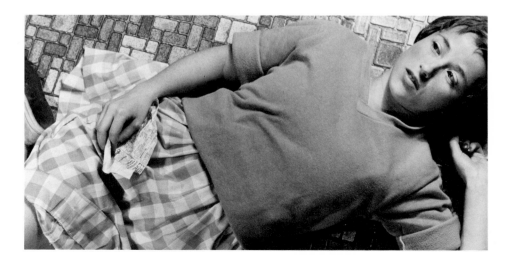

Cindy Sherman
Untitled 1981
(Sherman checklist no 9)

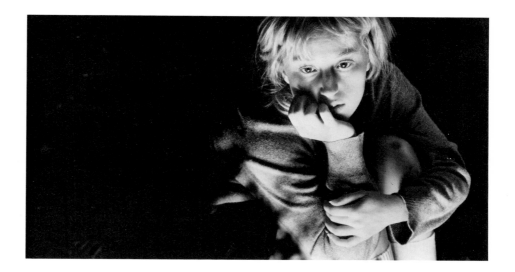

Cindy Sherman
Untitled 1981
(Sherman checklist no 10)

Sherman's recent color photographs grew out of a proposal to *Artforum* magazine to produce a *Playboy*-style centerfold. Thus, in most of the images we find her in various guises crouching on the floor or sprawling against rumpled bedsheets. Although there is no nudity, these close-up photos are charged with the limpid sexuality and psychological tensions that are the stock-in-trade of the centerfold genre. There is also something of the cinema about these photos with their wide-screen proportions, dramatic lighting and hyped-up color. Like movie posters designed to entice the public, each image implies but never thoroughly describes a narrative, and we are left to speculate on the precise nature of the drama in progress.

Unlike the women depicted in ordinary pin-up shots, Sherman's characters do not project romantic allure; rather their expressions are remote and ambiguous. In one photograph, Sherman seems to recoil in horror from an intruder just outside the frame; but in most of the photographs her gaze stays within the picture boundaries. Thus for all their superficial come-hither availability, the women seem remote and isolated, caught up in dark inner worlds of their own creation. As a result, the viewer who confronts these images is put in the unsettling position of voyeur, witness to intimately personal moments of vulnerability, suffering, anticipation or panic.[18]

"Anxiety," Yi-fu Tuan writes in his book *Landscapes of Fear,* "drives us to security, or, on the contrary, adventure. . . . The study of fear is therefore not limited to the study of withdrawal and retrenchment; at least implicitly, it also seeks to understand growth and adventure."[19] It is precisely in this questing spirit that the eight artists represented in this exhibition explore the theme of anxiety. Whether focusing on inner realms or on the real world, they evoke the uneasy mood of our times in their highly inventive creations.

18. *Ibid.*

19. Yi-fu Tuan, *Landscapes of Fear,* New York: Pantheon Books, 1979, p 10.

Jonathan Borofsky

Born in Boston, 1942
B.F.A., Carnegie Mellon University, 1964
M.F.A., Yale School of Art and Architecture, 1966
Lives in Venice, California

Checklist

Unless otherwise indicated all works are Courtesy Paula Cooper Gallery, New York

1. *Dream #1 at 1,944,821* 1972-73
oil, charcoal on canvas
6 panels: 48 x 60 each
4' x 30' assembled

2. *I Want to Run Away at 2,152,386* 1973
oil, charcoal on canvas board
20 x 16

3. *I Dreamed the Trees Behind My Parents' House Were Either Trimmed Bare or Removed at 2,170,250* 1973
oil, charcoal on canvas board
16 x 20

4. *Self-portrait at 2,182,473* 1973
oil, charcoal on canvas
24 x 20

5. *I Dreamed That Benita and I Were Fooling Around on the Train and We Practically Missed Our Plane (We Were Going to See Benita's Parents) at 2,192,865* 1973
oil, charcoal, ink on canvas board
18 x 24

6. *I Dreamed I Saw Buddy Rifkin . . . at 2,198,637* 1973
oil, charcoal on canvas board
16 x 20

7. *I Dreamed That Omar Sharif Was Nude . . . at 2,199,472* 1973
oil, charcoal on canvas board
20 x 16

8. *I Dreamed I Had a Moustache That Was Trimmed Too High at 2,206,687* 1973
charcoal on canvas board
20 x 16

9. *I Dreamed I Had To Smuggle Out Some Secret Documents Strapped to My Waist at 2,206,918* 1973
oil, charcoal on canvas board
20 x 16

10. *I Dreamed A Girl Was in Trouble and I Straightened Her Out at −6,300 + 2,228,727* 1973
ink on canvas
30⅛ x 36

11. *I Dreamed That a Man in a Tower Was Being Shot at 2,307,327* 1975
oil on canvas
58 x 58

12. *Running Man at 2,550,116* 1978-79
acrylic on plywood
89¼ x 110½
Collection Doris and Charles Saatchi, London

13. *Cambodian Mother Painting at 2,668,302* 1980
charcoal on canvas, bamboo pole, litter leaflets, plastic bucket and water, tin can and welding rod
101 x 58 x 90

14-21. 8 Original Dream Drawings 1972-79
mixed media, various dimensions
Collection the artist

22-45. Dream Drawings—second version redrawn from original notes for the catalogue *Dreams 1973-1981* which was published by the Institute of Contemporary Arts, London and the Kunsthalle, Basel
ink on paper
11⅝ x 8¼ each

Selected One Man Exhibitions

1975
Paula Cooper Gallery, New York
1976
Wadsworth Atheneum, Hartford, Connecticut
1977
University of California, Irvine
1978
Protetch-McIntosh Gallery, Washington, D.C.
University Art Museum, Berkeley
Foundation Corps de Garde, Gröningen, Holland
The Museum of Modern Art, New York
1979
INK, Halle fur Internationale Neue Kunst, Zurich
Portland Center for the Visual Arts, Oregon
1980
Paula Cooper Gallery, New York
Hayden Gallery, Massachusetts Institute of Technology, Cambridge
1981
Contemporary Arts Museum, Houston
Institute of Contemporary Arts, London/Kunsthalle, Basel
1982
Museum Boymans-van Beuningen, Rotterdam

Selected Group Exhibitions

1966
Wadsworth Atheneum, Hartford, Connecticut
1969
No. 7, Paula Cooper Gallery, New York
1973
Artists Space, New York
1975
Paula Cooper Gallery, New York
Narrative in Contemporary Art,
University of Guelph, Ontario
Autogeography, Whitney Museum of American Art, New York

1976
Venice Biennale, Italy
1977
New York: The State of Art, New York State Museum, Syracuse
1978
Minimal Image, Protetch-McIntosh Gallery, Washington, D.C.
Tenth Anniversary Group Show, Paula Cooper Gallery, New York
1979
Whitney Biennial, Whitney Museum of American Art, New York
1980
Drawings: The Pluralist Decade, American Pavilion, Venice Biennale, Italy
1981
Whitney Biennial, Whitney Museum of American Art, New York
Twenty Artists, Yale University Art Gallery, New Haven, Connecticut
The Museum as Site: Sixteen Projects, Los Angeles County Museum of Art

Selected Bibliography

1974
Lippard, Lucy. "Jonathan Borofsky at 2,096,974," *Artforum*, November, pp 63-64.
1976
Deitch, Jeffrey. "Before the Reason of Images: The New Work of Jon Borofsky," *Arts Magazine*, October, pp 98-99.
Rosenthal, Mark. *Jon Borofsky, Matrix 18*, Wadsworth Atheneum, Hartford, Connecticut.
1977
Bourdon, David. "Discerning the Shaman from the Showman," *The Village Voice*, July 4, p 83.
Sargent-Wooster, Ann. "New York Reviews," *Art News*, January, pp 121-122.
1978
Rosenthal, Mark. *Jon Borofsky/Megan Williams, Matrix/Berkeley 10*, University Art Museum, Berkeley.
――――――――. "From Primary Structures to Primary Imagery," *Arts Magazine*, October, pp 106-107.
Smith, Philip. "Jon Borofsky," *Arts Magazine*, March, p 13.
1979
Klein, Michael. "Jon Borofsky's Doubt," *Arts Magazine*, November, pp 122-123.
1980
Russell, John. "Art: Transformations of Jonathan Borofsky," *The New York Times*, October 24, sec C, p 23.
1981
Borofsky, Jonathan. "Strike: a Project by Jonathan Borofsky," *Artforum*, February, pp 50-56.
Flood, Richard. "Reviews: New York," *Artforum*, January, pp 70-71.
Simon, Joan. "Borofsky/Dreams," *Jonathan Borofsky: Dreams 1973-81*, Institute of Contemporary Arts, London.
――――――――. "An Interview with Jonathan Borofsky," *Art in America*, November, pp 156-167.

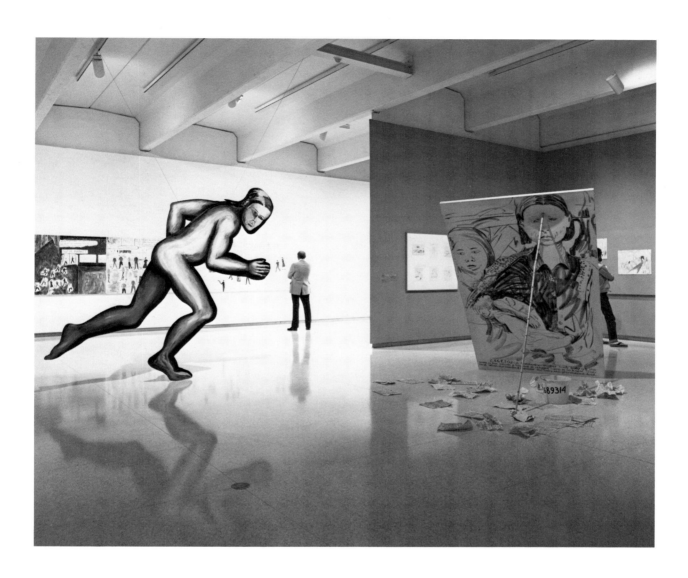

Jonathan Borofsky
Installation at Walker Art Center

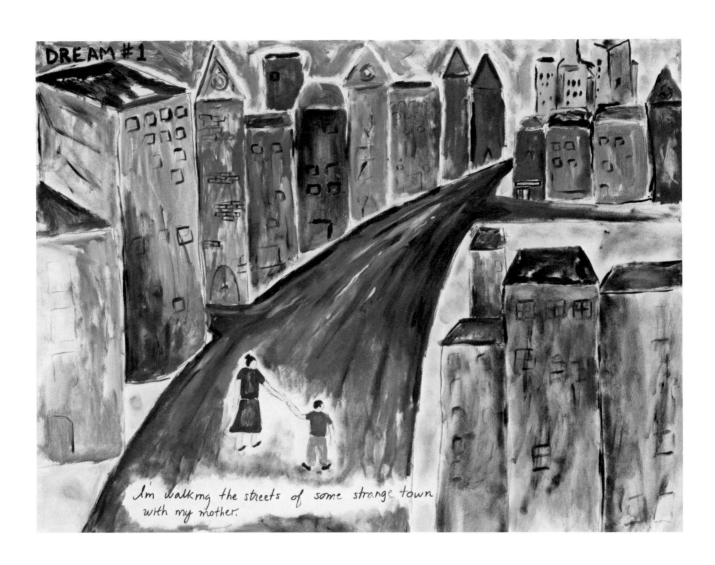

Dream #1 at 1,944,821 1972-73
(Detail, Borofsky checklist no 1)

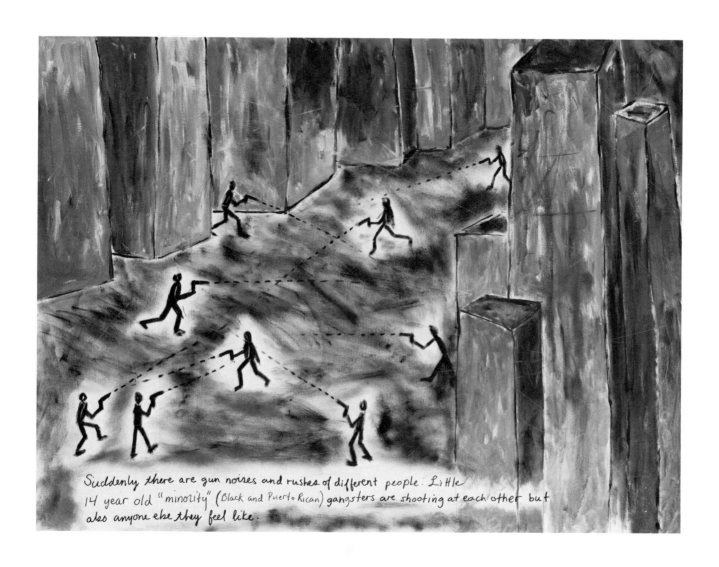

Dream #1 at 1,944,821 1972-73
(Detail, Borofsky checklist no 1)

Chris Burden

Born in Boston, 1946
B.A., Pomona College, 1969
M.F.A., University of California, Irvine, 1971
Lives in Los Angeles

Checklist

1-8. *Devil Drawings* 1979
collage on paper
30 x 40 each:

Strangler Hunt Grows
Creatures Beyond Fathom of Science
Spook Planes
Thank You
Collection the artist; courtesy Ronald Feldman
Fine Arts, Inc., New York

Here Comes Trouble
Courtesy Ronald Feldman Fine Arts, Inc., New York

Gallant Gallic Warrior
What Price Glory?
Chris
Collection the artist; courtesy Rosamund Felsen
Gallery, Los Angeles

9-15. Collection the artist; courtesy Rosamund
Felsen Gallery, Los Angeles:

Pick and Bottle of Alcohol 1979
alcohol in glass bottle, pick in glass and wood case
12 x 23 x 19

16th Century Gunpowder 1979
mortar and pestle, charcoal, potassium nitrate,
sulphur in glass and wood case
12¼ x 25 x 12

T.V.s and Hat 1979
two portable televisions, hat in
glass and wood case
16 x 21 x 16

Survival Kit 1979
tin box, red cloth, transistor radio, mirror, $100 bill,
candle, matches, toothbrush, camping saw, foldout
utensils, fishing hook and line, cigarettes in
glass and wood case
11 x 20 x 20

Airplane and Barbed Wire 1979
model airplane, barbed wire in
glass and wood case
16¼ x 31 x 17

Radio Sculpture 1979
radio, speakers, objects in glass and wood case
28⅛ x 15 x 14

Spy Kit 1979
tin box, gray cloth, walkie-talkie, razor blade, spy
glass, cigarette lighter in glass and wood case
10¼ x 17 x 17

16. *Case of Street Weapons* 1979
stick, car antenna, elastic cord with rolled up tin can
lid and razor blade, paper tube dart gun with
homemade dart in glass and wood case
11¼ x 46 x 18
Collection Mr. and Mrs. James Harithas, New York

17. *The Big Wheel* 1979
cast iron flywheel, wood, steel, motorcycle
9'4 x 14'7 x 11'11
Collection the artist; courtesy Rosamund Felsen
Gallery, Los Angeles
Motorcycle courtesy WIW Cycle Center, Inc.,
Minneapolis

18. *Leading Edge of Nuclear Fireball* 1980
Ed Ruscha silkscreen on paper modified by Chris
Burden with gouache, watercolor, ink
14¾ x 42¼
Collection Richard Grossman, Minneapolis

Selected Performances and Installations

1971
Five Day Locker Piece, University of California,
Irvine, April 26-30
Prelude to 220 or 110, F Space, Santa Ana,
California, September 10-12
Shoot, F Space, Santa Ana, California,
November 19
1972
Bed Piece, Venice, California, February 18-
March 10
1973
747, Los Angeles, January 5
Through the Night Softly, Los Angeles,
September 12
Doorway to Heaven, Venice, California,
November 15
1974
Trans-Fixed, Venice, California, April 23
Kunst Kick, Ronald Feldman Fine Arts, Basel Art Fair,
Switzerland, June 19
1975
White Light/White Heat, Ronald Feldman Fine Arts,
New York, February 8-March 1
1977
CBTV, Documenta 6, Kassel, West Germany, June
1978
The Citadel, Los Angeles, August 8-12
1979
Pearl Harbor, Santa Barbara National Guard
Armory, California, December 8
1981
*There Have Been Some Pretty Wild Rumors About
Me Lately,* San Francisco Video Festival,
October 28

Selected One Man Exhibitions

1974
Riko Mizuno Gallery, Los Angeles
Ronald Feldman Fine Arts, New York
Contemporary Arts Center, Cincinnati
1975
Ronald Feldman Fine Arts, New York
Galleria Allessandra Castelli, Milan
Galerie Stadler, Paris
1976
Ronald Feldman Fine Arts, New York
Broxton Gallery, Los Angeles

1977
Ronald Feldman Fine Arts, New York
Jan Baum/Iris Silverman Gallery, Los Angeles
1979
Ronald Feldman Fine Arts, New York
1982
Rosamund Felsen Gallery, Los Angeles

Selected Group Exhibitions

1975
Via Los Angeles, Portland Center for the Visual Arts,
Oregon
1976
Twenty Years of California Art, San Francisco
Museum of Modern Art
1977
Whitney Biennial, Whitney Museum of American
Art, New York
1980
Sculpture in California, 1975-80, San Diego Museum
of Art
Tableaux, Los Angeles Institute of Contemporary
Art
1981
The Museum as Site: Sixteen Projects, Los Angeles
County Museum of Art
1982
War Games, Ronald Feldman Fine Arts, New York

Selected Bibliography

1973
Bear, Liza and Sharp, Willoughby. "Chris Burden:
The Church of Human Energy," *Avalanche,* No. 8,
Summer/Fall, pp 54-55.
1974
Bear, Liza. "Chris Burden . . . Back to You,"
Avalanche, May/June, pp 12-13.
Collins, Jim. "Reviews," *Artforum,* May, pp 72-73.
1975
Bourdon, David. "Body Artists without Bodies,"
The Village Voice, February 24, pp 85-86.
Butterfield, Jan and Burden, Chris. "Chris Burden:
Through the Night Softly," *Arts Magazine,* March,
pp 68-72.
1976
Horvitz, Robert. "Chris Burden," *Artforum,* May,
pp 24-31.
1978
Pluchart, Francois. "Risk as the Practice of
Thought," *Flash Art,* February-April, pp 39-40.
1979
Cavaliere, Barbara. "Chris Burden," *Arts Magazine,*
June, p 4.
Hoffman, Fred. "Chris Burden's Humanism,"
Artweek, October 27, pp 1, 16.
Rickey, Carrie. "The Reason for the Neutron Bomb,"
Flash Art, June-July, p 43.
1980
Clothier, Peter. "Chris Burden: the Artist as Hero,"
Flash Art, January-February, pp 49-50.
1982
Plagens, Peter. "Site Wars," *Art in America,*
January, pp 90-98.

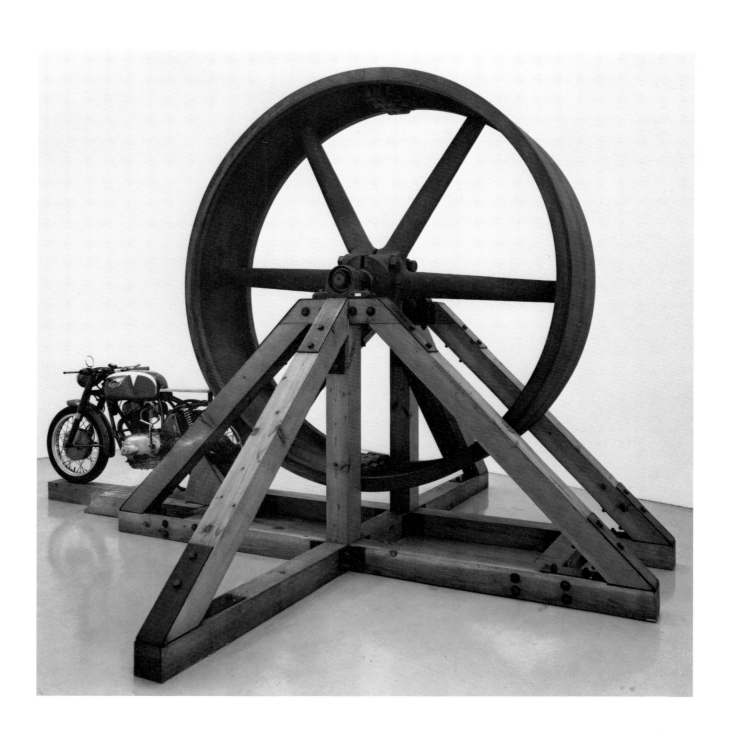

The Big Wheel 1979
(Burden checklist no 17)

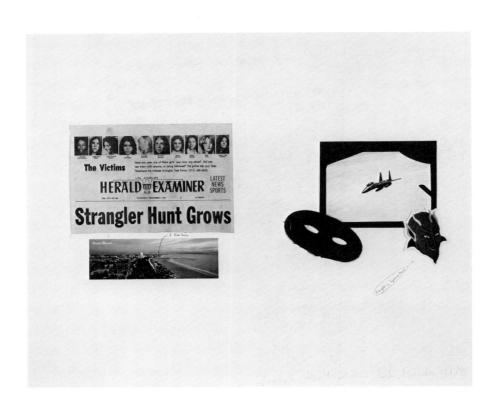

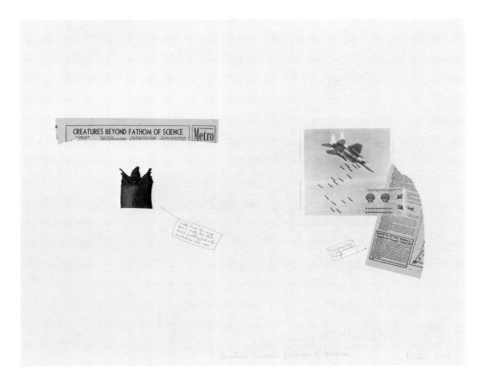

Strangler Hunt Grows 1979
Creatures Beyond Fathom of Science 1979
(Burden checklist nos 1, 2)

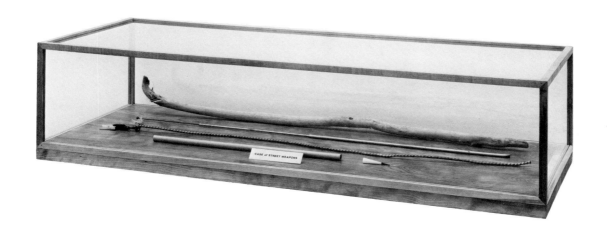

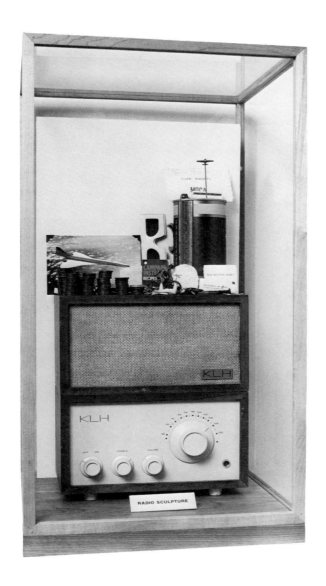

Case of Street Weapons 1979
Radio Sculpture 1979
(Burden checklist nos 16, 14)

Bruce Charlesworth

Born in Davenport, Iowa, 1950
B.A., University of Northern Iowa, 1972
M.A., University of Iowa, 1974
M.F.A., University of Iowa, 1975
Lives in Minneapolis

Checklist

1. *Projectile* 1982
mixed media environmental installation
11'2 x 36' x 33'
Commissioned for the exhibition

Selected One Man Exhibitions

1975
Doris Day in Flames, University of Iowa,
Iowa City
1979
Glen Hanson Gallery, Minneapolis
1980
Eddie Glove, Walker Art Center, Minneapolis
1981
Special Communiqués, Film in the Cities, St. Paul
1982
Lost Dance Steps, Artists Space, New York

Selected Group Exhibitions

1977
Iowa Artists, Des Moines Art Center, Iowa
1979
SX-70, Center for Exploratory and Perceptual Arts,
Buffalo, New York
American Vision, Washington Square East
Galleries, New York
Recent Acquisitions, Minneapolis Institute
of Arts
1980
Likely Stories, Castelli Graphics, New York
Instantanés, Musée National d'Art Moderne, Paris
Painting/Drawing, Kiehle Gallery, St. Cloud State
University, Minnesota
1981
Persona, The New Museum, New York
Five Emerging Artists, Minneapolis College of Art
and Design
Selections from the Permanent Collection: 1969-80,
Minneapolis Institute of Arts

Selected Bibliography

1979
Hegeman, William. "Looking at Art," *Minneapolis
Tribune,* September 2, sec G, p 10.
1980
Grundberg, Andy. "Fairy Tales," *The Soho News,*
July 23, p 34.
Hegeman, William. "Charlesworth Photos Odd but
Compelling," *Minneapolis Tribune,* July 27, sec G,
p 3.
King, Shannon. "Artist Develops Tale with Photos,"
Minneapolis Star, August 1, sec C, p 6.
Lifson, Ben. "Summer Stock," *The Village Voice,*
July 16, p 72.
Thornton, Gene. "Narrative works,"
The New York Times, August 30, sec D, p 19.
1981
Bowsher, John. "Bruce Charlesworth,"
Five Emerging Artists, Minneapolis
College of Art and Design.
Gumpert, Lynn and Rifkin, Ned. "Bruce
Charlesworth," *Persona,* The New Museum,
New York.
Perrault, John. "Masked Marvels," *The Soho News,*
October 27, p 59.

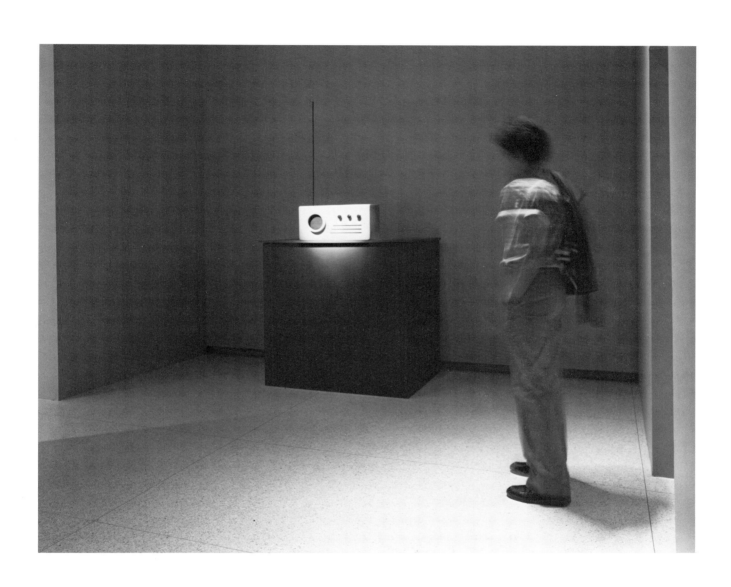

Radio Room
(part of *Projectile* 1982,
Charlesworth checklist no 1)

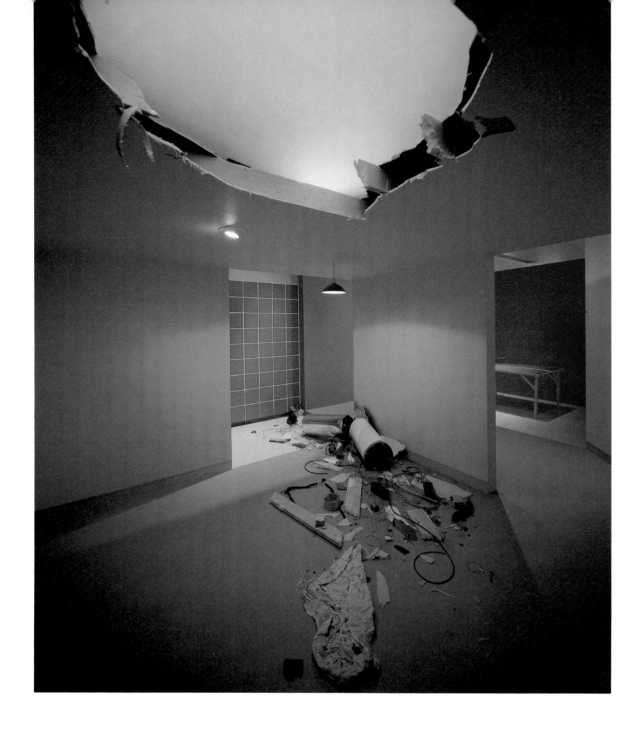

Impact Room
(part of *Projectile* 1982,
Charlesworth checklist no 1)

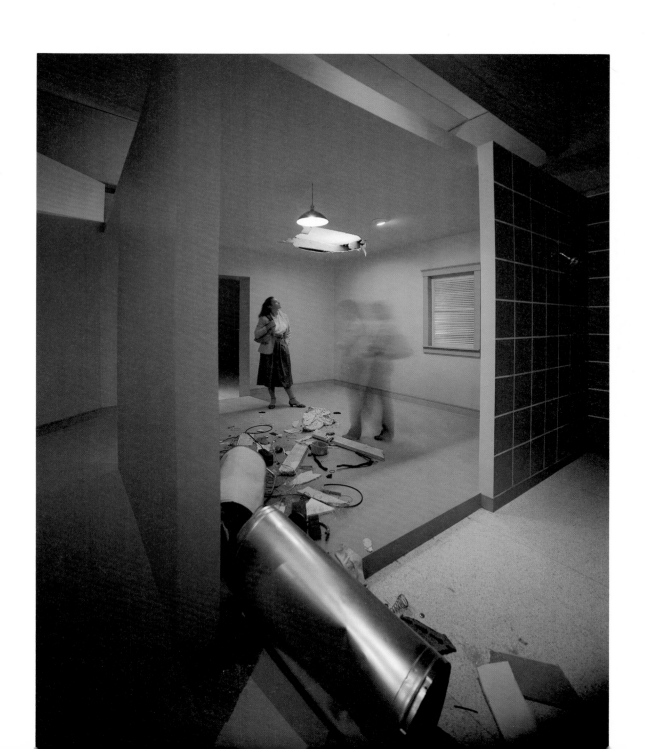

Robert Longo

Born in New York, 1953
B.F.A., State University College, Buffalo,
New York, 1972
Lives in New York

Checklist

1. *The Swing* 1979
cast aluminum
21 x 38 x 5
Private Collection, New York

2. *The Pilots* 1979
lacquer on cast aluminum
66 x 48 x 5
Courtesy Metro Pictures, New York

3. *The Wrestlers* 1979
lacquer on aluminum
bonded to cast fiberglass
44 x 48 x 6
Courtesy Metro Pictures, New York

4. *Untitled (Men in the Cities)* 1980
lacquer on aluminum
bonded to cast fiberglass
3 pieces: 65 x 37½ each; 65 x 112½ assembled
Collection the artist; courtesy Metro Pictures,
New York

5. *The Silence* 1980
lacquer on plaster
22 x 38 x 5
Courtesy Metro Pictures, New York

6. *Untitled (Men in the Cities)* 1981
charcoal, graphite on paper
96 x 60
Courtesy Metro Pictures, New York

7. *Untitled (Men in the Cities)* 1981
charcoal, graphite on paper
96 x 60
Collection Phoebe Chason, New York

8. *Untitled* 1981
charcoal, graphite on paper
62 x 72
Collection Doris and Robert Hillman, New York

9. *Untitled* 1981
charcoal, graphite on paper
60 x 60
Collection Mr. and Mrs. Eugene M. Schwartz,
New York

10. *The National Trust* 1981
charcoal, graphite on paper and aluminum
bonded to cast fiberglass
two drawings: 48 x 96 each;
relief: 34 x 48
Collection Walker Art Center; Art Center
Acquisition Fund

Selected Performances

1976
Temptation to Exit/Things I Will Regret, Artists
Space, New York
Artful Dodger/L'espace comme Fiction, Hallwalls,
Buffalo, New York
The Buffalo Saga Is Over, private residence, Buffalo,
New York
1979
Pictures for Music, Mudd Club, New York
Surrender, The Kitchen, New York
Empire: A Performance Trilogy, The Corcoran
Gallery of Art, Washington, D.C.
1981
Whitney Museum of American Art, New York.
(with Rhys Chatham)

Selected One Man Exhibitions

1974
Gallery 220, State University College, Buffalo,
New York
1976
Object Fictions, Hallwalls, Buffalo, New York
1977
The Kitchen, New York
1978
Sound Distance of a Good Man, Franklin Furnace,
New York
1979
Boys Slow Dance, The Kitchen, New York
1981
Metro Pictures, New York
Larry Gagosian Gallery, Los Angeles
1982
Texas Gallery, Houston

Selected Group Exhibitions

1975
Working on Paper, Hallwalls, Buffalo, New York
1976
Hallwalls, Artists Space, New York
Noise, Hallwalls, Buffalo, New York
1977
In Western New York, Albright-Knox Art Gallery,
Buffalo, New York
Pictures, Artists Space, New York
1979
Masters of Love, 80 Langton Street, San Francisco
Re: Figuration, Max Protetch Gallery, New York
1980
*Extensions: Jennifer Bartlett, Lynda Benglis, Robert
Longo, Judy Pfaff,* Contemporary Arts Museum,
Houston
Illustration and Allegory, Brooke Alexander, Inc.,
New York
Opening Group Exhibition, Metro Pictures,
New York
Drawings and Paintings on Paper, Annina Nosei
Gallery, New York

1981
Tableaux, Wave Hill, New York
Westkunst, Heute, Cologne
Represent-Representation-Representative, Brooke
Alexander, Inc., New York
The Anxious Figure, Semaphore Gallery,
New York
Relief Sculpture, P.S. 1, New York
Body Language: Figurative Aspects of Recent Art,
Hayden Gallery, Massachusetts Institute of
Technology, Cambridge
Figures: Forms and Expressions, Albright-Knox Art
Gallery, Buffalo, New York
1982
A Few Good Men, Portland Center for the Visual
Arts, Oregon
Dynamix, Contemporary Arts Center, Cincinnati

Selected Bibliography

1977
Crimp, Douglas. *Pictures,* Artists Space, New York.
1978
Frank, Peter. "Pictures and Meaning," *Artweek,*
April 29, p 5.
Lawson, Thomas. *"Pictures* at Artists Space,"
Art in America, January/February, p 118.
1979
Cathcart, Linda. *In Western New York,* Albright-
Knox Art Gallery, Buffalo, New York.
Crimp, Douglas. "Pictures," *October,* Spring,
pp 75-88.
Goldberg, Roselee. *Performance: Live Art 1909 to
Present,* Harry N. Abrams, Inc., New York, p 122.
Lawson, Thomas. "The Uses of Representation:
Making Some Distinctions," *Flash Art,* March/April,
pp 37-39.
1980
Cathcart, Linda. *Extensions: Jennifer Bartlett, Lynda
Benglis, Robert Longo, Judy Pfaff,* Contemporary
Arts Museum, Houston.
Owens, Craig. "The Allegorical Impulse: Toward a
Theory of Postmodernism," *October,* Spring,
pp 67-86.
Ratcliff, Carter. *Illustration and Allegory,* Brooke
Alexander, Inc., New York.
Siegel, Jeanne. "Lois Lane and Robert Longo:
Interpretation of Image," *Arts Magazine,*
November, pp 154-157.
1981
Atkins, Robert. "Robert Longo at the Corcoran Art
School," *Images and Issues,* Fall, pp 74-75.
Blinderman, Barry. "Robert Longo's *Men in the
Cities,*" *Arts Magazine,* March, pp 92-93.
Crimp, Douglas. "The Photographic Activity of
Postmodernism," *October,* Winter, pp 91-102.
Levin, Kim. *Tableaux,* Wave Hill, New York.
Owens, Craig. "Robert Longo at Metro Pictures,"
Art in America, March, pp 125-126.
Ratcliff, Carter. "Art Stars for the Eighties,"
Saturday Review, Feburary, pp 12-20.

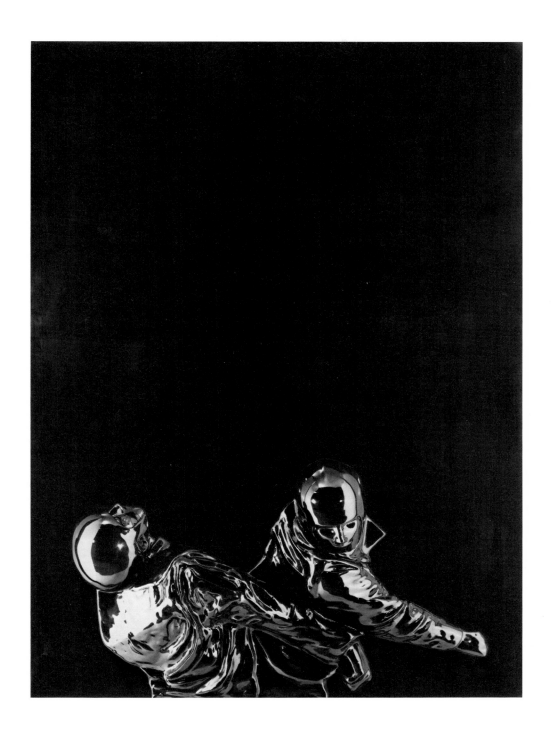

The Pilots 1979
(Longo checklist no 2)

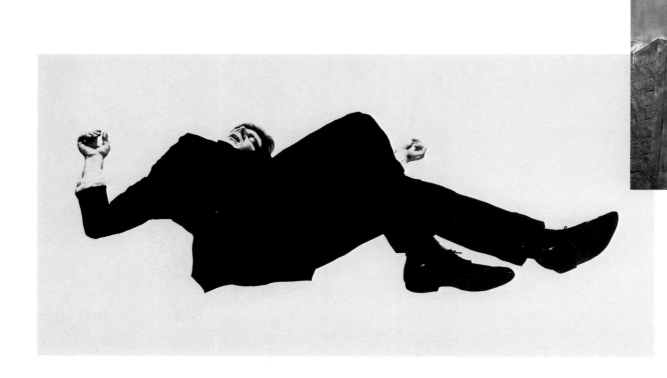

The National Trust 1981
(Longo checklist no 10)

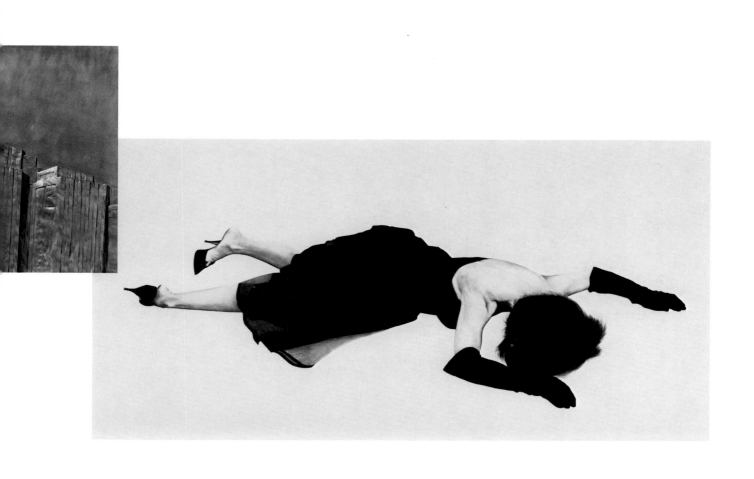

David Salle

Born in Norman, Oklahoma, 1952
B.F.A., California Institute of Arts, 1973
M.F.A., California Institute of Arts, 1975
Lives in New York

Checklist

1. *The Illustrator is There* 1981
oil, acrylic on canvas
84 x 60
Collection the artist; courtesy Mary Boone/
Leo Castelli, New York

2. *A Number of My Subjects* 1981
oil, acrylic on canvas
3 panels: 90 x 50; 90 x 50; 70 x 41
90 x 142 assembled
Private Collection, New York

3. *Feasibility* 1981
oil, acrylic on canvas
2 panels: 58 x 42 each; 58 x 84 assembled
Collection Mr. and Mrs. Charles M. Diker,
New York

4. *Proust or Canada* 1981
oil, acrylic on canvas
2 panels: 58 x 42 each; 58 x 84 assembled
Collection Herbert and Lee Schorr, Briarcliff Manor,
New York

5. *A Long Life* 1981
acrylic on canvas
86 x 112
Collection Barry Lowen, Los Angeles

6. *My Subjectivity* 1981
acrylic on canvas and masonite
2 panels: 86 x 56 each; 86 x 112 assembled
Collection Paine Webber Inc., New York

7. *A Couple of Centuries* 1982
acrylic, oil on canvas
2 panels: 110 x 80 each; 110 x 160 assembled
Collection Doris and Charles Saatchi, London

Selected One Man Exhibitions

1975
Project, Inc., Cambridge, Massachusetts
Claire S. Copley Gallery, Los Angeles
1976
Foundation Corps de Garde, Gröningen, Holland
Artists Space, New York
1977
Foundation de Appel, Amsterdam
The Kitchen, New York
1978
Real Art Ways, Hartford, Connecticut
1979
Gagosian/Nosei-Weber Gallery, New York
The Kitchen, New York
1980
Annina Nosei Gallery, New York
Galerie Bischofberger, Zurich
1981
Mary Boone Gallery, New York
Larry Gagosian Gallery, Los Angeles
1982
Mary Boone Gallery, New York
Leo Castelli Gallery, New York

Selected Group Exhibitions

1975
Southland Video Anthology, Long Beach
Museum of Art, California
1977
Locations, Serial Gallerie, Amsterdam
Hallwalls, Buffalo, New York
New Art Auction and Exhibition, Artists Space,
New York
1978
Summer Festival, Gröninger Museum, Holland
1979
Recognizable Images, Studio Cannaviello, Milan
Hal Bromm Gallery, New York
Masters of Love, 80 Langton Street, San Francisco
1980
Mary Boone Gallery, New York
L'Amerique aux Independants, Grand Palais, Paris
Illustration and Allegory, Brooke Alexander, Inc.,
New York
1981
Annina Nosei Gallery, New York
Young Americans, Allen Memorial Art Museum,
Oberlin College, Ohio
Westkunst, Heute, Cologne
Mary Boone Gallery, New York
Sperone Westwater Fischer, New York
Tenth Anniversary Exhibition, California Institute
of the Arts, Valencia
Figures: Forms and Expressions, Albright-Knox Art
Gallery, Buffalo, New York
Figurative Aspects of Recent Art, Hayden Gallery,
Massachusetts Institute of Technology, Cambridge
Nigel Greenwood Gallery, London

Selected Bibliography

1975
Askey, Ruth. "On Video: Banality, Sex, Cooking,"
Artweek, August 9, p 5.
1979
Lawson, Thomas. "The Uses of Representation:
Making Some Distinctions," *Flash Art,* March/April,
pp 37-39.
Salle, David. "The Paintings Are Dead," *Cover,*
May.
Tatransky, Valentin. "Intelligence and the Desire to
Draw: On David Salle," *Real Life,* November.
1980
Hess, Elizabeth. "Barefoot Girls with Cheek Gloss,"
The Village Voice, November 19, p 93.
Lawson, Thomas. "David Salle," *Flash Art,* January/
February, p 33.
Robinson, Walter. "David Salle at Gagosian/Nosei-
Weber," *Art in America,* March, pp 117-118.
Salle, David. "Images that Understand Us: A
Conversation with David Salle and James Welling,"
Journal, June/July, pp 41-44.
1981
Collins, Dan and Hicks, Emily. "Meaning through
Disparity," *Artweek,* May 9, p 3.
Lawson, Thomas. "Last Exit: Painting," *Artforum,*
October, pp 40-47.
Pincus-Witten, Robert. "Entries: Sheer Grunge,"
Arts Magazine, May, pp 93-97.
"Post-Modernism," (panel discussion), *Real Life,*
Summer, pp 4-10.
Ratcliff, Carter. "Westkunst: David Salle," *Flash Art,*
Summer, pp 33-34.
_____ . "David Salle: A Matter of
Interrogation," *Young Americans,* Allen Memorial
Art Museum, Oberlin College, Ohio.
Salle, David. "David Salle," *File Magazine,* Vol. 5,
No. 2.
Schjeldahl, Peter. "David Salle Interview," *Journal,*
September/October, pp 15-21.
Siegel, Jeanne. "David Salle: Interpretation of
Image," *Arts Magazine,* April, pp 94-95.
1982
Ratcliff, Carter. "An Attack on Painting,"
Saturday Review, January, pp 50-51.
_____ . "David Salle," *Interview,*
February, pp 64-65.
Schjeldahl, Peter. "David Salle's Objects of
Disaffection," *The Village Voice,* March 23, p 83.

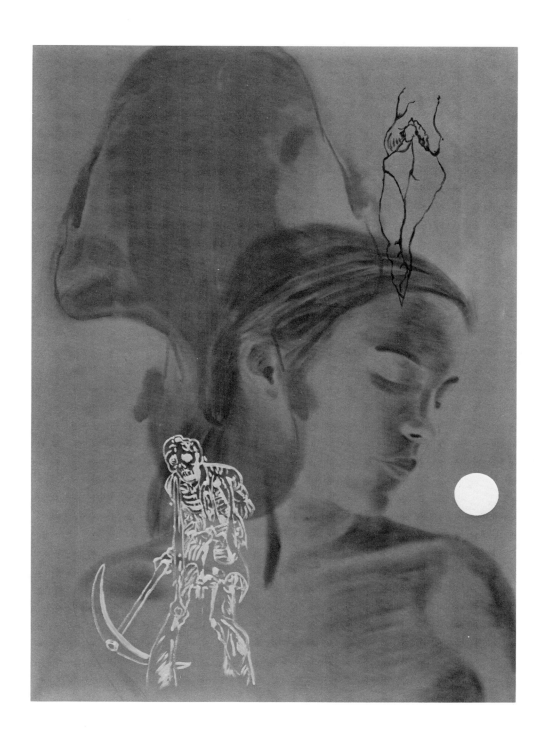

The Illustrator is There 1981
(Salle checklist no 1)

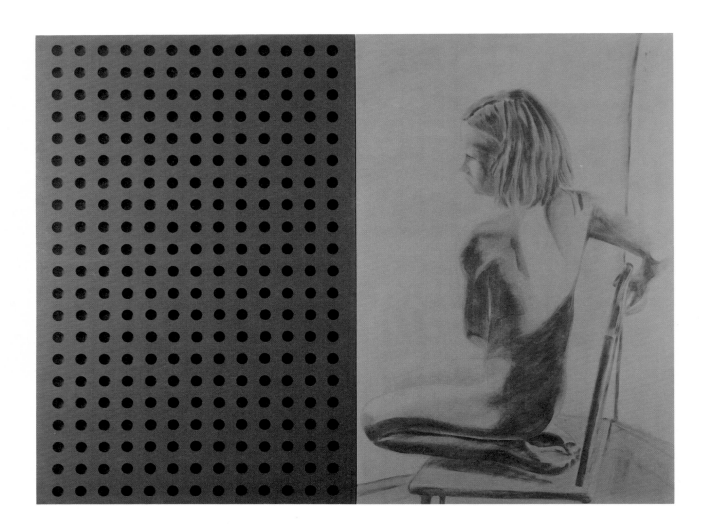

My Subjectivity 1981
(Salle checklist no 6)

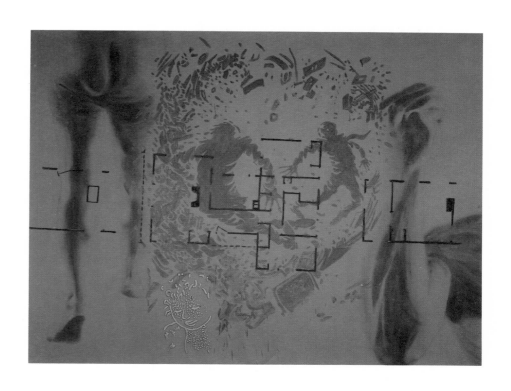

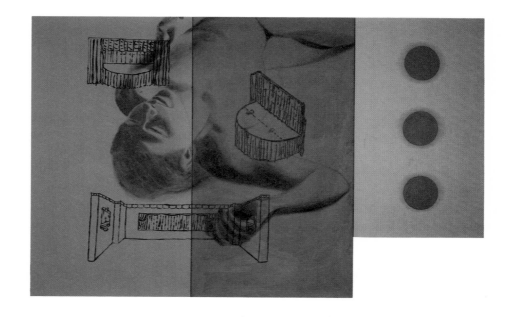

A Long Life 1981
A Number of My Subjects 1981
(Salle checklist nos 5,2)

Italo Scanga

Born in Lago, Calabria, Italy, 1932
B.A., Michigan State University, 1960
M.A., Michigan State University, 1961
Lives in La Jolla, California

Checklist

All works are painted wood, wire, found objects

1. *Fear of Success* 1980
86 x 20 x 12
Collection Barbara Brooker, San Francisco

2. *Fear of Buying a House* 1980
60 x 24 x 10
Collection Mary Donovan, San Francisco

3. *Fear of Dreams (to Jackson Pollock)* 1980
75 x 38 x 9
Collection Wally Goodman, San Francisco

4. *Fear of Nature* 1980
77½ x 15 x 10½
Private collection, San Francisco

5. *Fear of Fire* 1980
72 x 27 x 16
Private collection, San Francisco

6-7. Collection the artist; courtesy RoseWeb
Projects, New York:

Fear of Earthquakes 1980
56 x 32 x 10

Fear of Buying a House 1980
73 x 32½ x 22

8-18. Courtesy Daniel Weinberg Gallery,
San Francisco:

Fear of War 1980
72 x 16 x 11

Fear of Volcanoes 1980
68 x 20 x 4

Fear of the Metric System 1980
62 x 11½ x 9

Fear of Hunger 1980
92 x 15 x 16

Fear of Marriage 1980
69 x 9 x 9

Fear of Work 1980
82 x 24 x 13½

Fear of Drinking 1980
47 x 24 x 13½

Fear of Lightning 1980
66½ x 31 x 16

Fear of Children 1980
73 x 24 x 17

Fear of Old Age 1980
50 x 9 x 8

Fear of the Arts 1981
74 x 50 x 18

19-21. Collection the artist:

Fear of Darkness 1981
71½ x 20½ x 14

Fear of Drinking 1981
58 x 13½ x 10

Fear of Children 1981
74 x 26½ x 14

22. *Melancholy* 1981
82½ x 12 x 10
Collection Rena Bransten, San Francisco

Selected One Man Exhibitions

1969
Baylor Art Gallery, Baylor University, Waco, Texas
1970
Rhode Island School of Design, Providence
Tyler School of Art, Philadelphia
1971
Henri Gallery, Washington, D.C.
University of Massachusetts Art Gallery, Amherst
1972
Tyler School of Art, Rome
Whitney Museum of American Art, New York
1973
112 Greene Street Gallery, New York
1975
Alessandra Gallery, New York
1977
Alessandra Gallery, New York
1978
Henri Gallery, Washington, D.C.
The Clocktower, New York
1979
San Jose State University Art Gallery, California
1980
Frank Kolbert Gallery, New York
1981
Daniel Weinberg Gallery, San Francisco

Selected Group Exhibitions

1971
112 Greene Street Gallery, New York
Six Sculptors: Extended Structures, Museum of
Contemporary Art, Chicago
1973
Made in Philadelphia, The Institute of
Contemporary Art, University of Pennsylvania,
Philadelphia
Story, John Gibson Gallery, New York

1974
Narrative 2, John Gibson Gallery, New York
1975
Narrative in Contemporary Art, University of
Guelph, Ontario
1977
Carpenter, Chihuly, Scanga, The Seattle Museum
of Art
1978
Despair, Albright-Knox Art Gallery, Buffalo,
New York
1979
Four in San Diego, University Art Gallery, San Diego
State University
1980
Italo Scanga, Robyn Denny, Thomas Babeor
Gallery, La Jolla, California
Sculpture in California, 1975–80, San Diego
Museum of Art
1981
Americans in Glass, Cooper-Hewitt Museum,
New York
Figuratively Sculpting, P.S. 1, New York
Tableaux, Wave Hill, New York
1982
Personal Iconography, The Sculpture Center,
Hunter College, New York

Selected Bibliography

1977
Cameron, Eric. "Italo Scanga's Torn Loyalties,"
Artforum, January, pp 51-53.
1978
Onorato, Ronald. "Reviews New York," *Artforum,*
September, p 78.
Rosengarden, Linda. "Italo Scanga's Reformation,"
LAICA Journal, October/November.
Saunders, Wade. "Italo Scanga," *Art in America,*
September/October, p 26.
1979
Burkhart, Dorothy. "Spiritual Feast, Social Famine,"
Artweek, November 17.
1980
Knaut, Bob. "Italo Scanga at Kolbert," *Art in
America,* November, p 136.
Knight, Christopher. "Italo Scanga," *Artforum,*
November, p 94.
Larson, Kay. "Little Disturbances of Man,"
The Village Voice, October 1, p 109.
1981
White, Robyn. "Italo Scanga," *View,* Crown Point
Press, Oakland, California.
1982
Knight, Christopher. "Scanga's Object-Ciphers,"
Art Express, January/February, pp 29-33.
Onorato, Ronald. "Some Make It Hot: Italo Scanga,"
Art Express, January/February, pp 28.

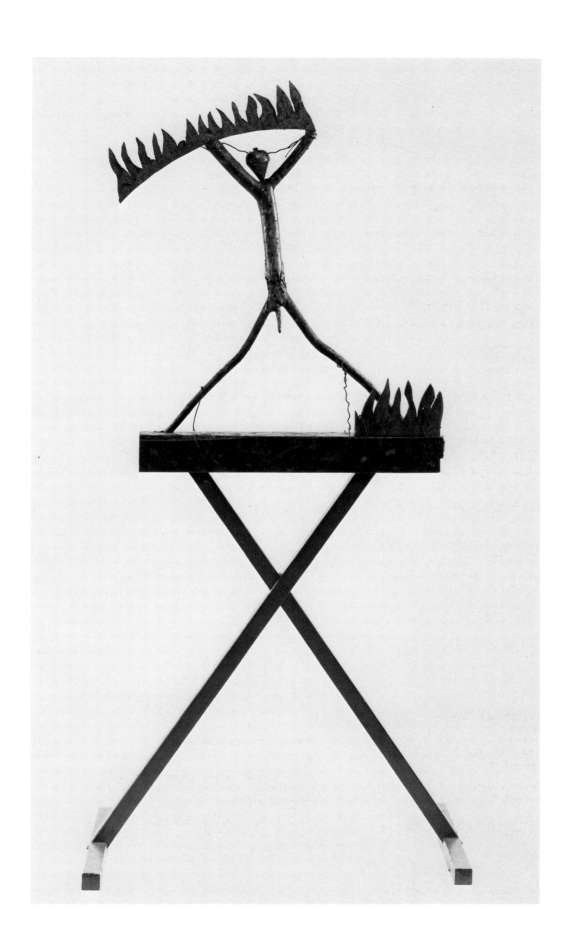

Fear of Fire 1980
(Scanga checklist no 5)

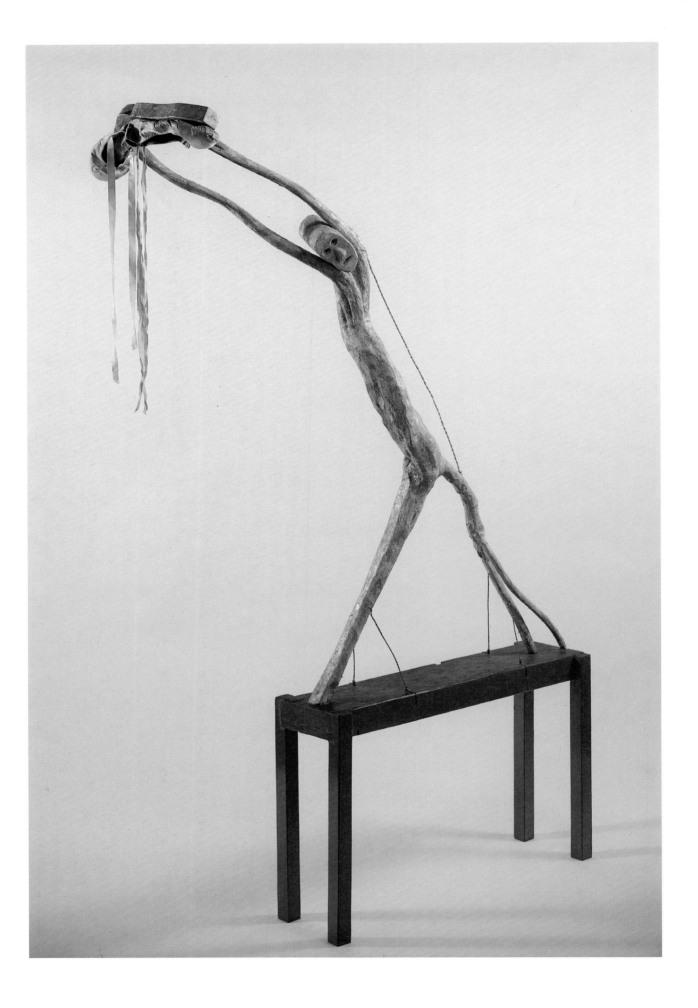

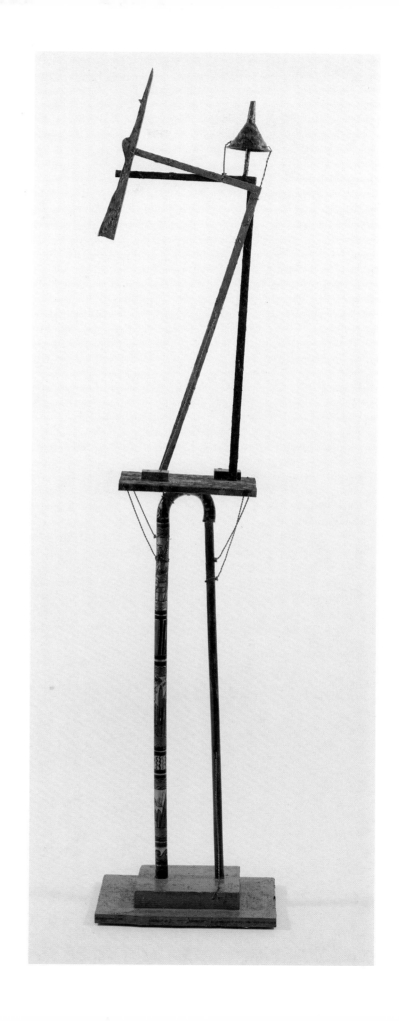

Fear of the Arts 1981
Fear of War 1980
(Scanga checklist nos 18,8)

Cindy Sherman

Born in Glen Ridge, New Jersey, 1954
B.A., State University College, Buffalo, 1976
Lives in New York

Checklist

1-8. *Untitled Film Stills* 1977-80
black and white photographs
8 x 10 each
Courtesy Metro Pictures, New York

9-18. *Untitled* 1981
color photographs
24 x 48 each
Collection the artist; courtesy Metro Pictures,
New York

Selected One Woman Exhibitions

1976
Hallwalls, Buffalo, New York
1977
Hallwalls, Buffalo, New York
Visual Studies Workshop, Rochester, New York
1979
Hallwalls, Buffalo, New York
1980
Contemporary Arts Museum, Houston
The Kitchen, New York
Metro Pictures, New York
1981
Metro Pictures, New York
1982
Texas Gallery, Houston

Selected Group Exhibitions

1975
Albright-Knox Art Gallery, Buffalo, New York
Hallwalls, Buffalo, New York
CEPA Gallery, Buffalo, New York
1976
Hallwalls, Artists Space, New York
Albright-Knox Art Gallery, Buffalo, New York
1977
Albright-Knox Art Gallery, Buffalo, New York
1978
Four Artists, Artists Space, New York
N.A.M.E. Gallery, Chicago
Floating Museum, San Francisco
1979
Re: Figuration, Max Protetch Gallery, New York
Roanoke University Gallery, Virginia
1980
Remembrances for Tomorrow, New 57 Gallery,
Edinburgh, Scotland
Likely Stories, Castelli Graphics, New York
Opening Group Exhibition, Metro Pictures,
New York
An International Exhibition of Fourteen New Artists,
Lisson Gallery, London
1981
Representation, University of Hartford,
Connecticut
Young Americans, Allen Memorial Art Museum,
Oberlin College, Ohio
Couches, Diamonds and Pie, P.S. 1, New York
Love Is Blind, Castelli Photographs, New York
On Location, Texas Gallery, Houston
Landesmuseum Bonn, West Germany
Autoportraits, Musée d'Art Moderne, Paris
Body Language: Figurative Aspects of Recent Art,
Hayden Gallery, Massachusetts Institute of
Technology, Cambridge
Art For ERA, Zabriskie Gallery, New York

Selected Bibliography

1979
Cathcart, Linda. *In Western New York,* Albright-
Knox Art Gallery, Buffalo, New York.
1980
Cathcart, Linda. *Hallwalls 5 Years,* Hallwalls,
Buffalo, New York.
_____ . *Cindy Sherman:
Photographs,* Contemporary Arts Museum,
Houston.
Lifson, Ben. "Masquerading," *The Village Voice,*
March 31, p 77.
1981
Crimp, Douglas. "The Photographic Activity of
Postmodernism," *October,* Winter, pp 91-102.
_____ . "Cindy Sherman: Making
Pictures for the Camera," *Young Americans,* Alle
Memorial Art Museum, Oberlin College, Ohio.
Flood, Michael. "Reviews New York," *Artforum,*
March, p 80.
Grundberg, Andy. "Cindy Sherman: A Playful and
Political Postmodernist," *The New York Times,*
November 22, p 35.
Klein, Michael. "Cindy Sherman," *Arts Magazine,*
March, p 5.
Lifson, Ben. "Fashionable Featur
The Village Voice, December 2
1982
Gambrell, Jamey. "Cindy Sherma
Pictures," *Artforum,* February, pp 85-
Schjeldahl, Peter. "Shermanettes," *Art . .a,*
March, pp 110-111.

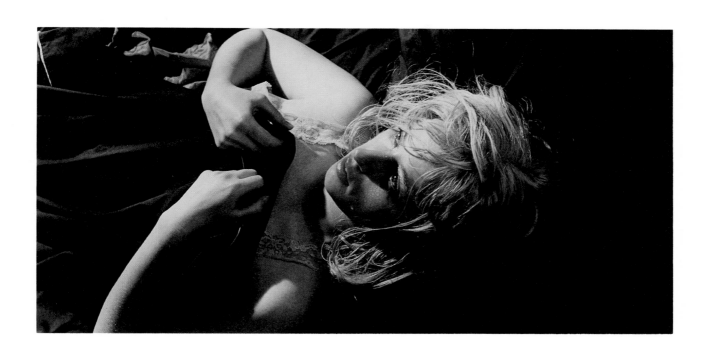

Untitled 1981
(Sherman checklist no 12)

Hollis Sigler

Born in Gary, Indiana, 1946
B.F.A., Moore College of Art, 1970
M.F.A., School of The Art Institute of Chicago, 1973
Lives in Prairie View, Illinois

Checklist

A Journey to Somewhere from Nowhere 1981

9 drawings, Craypas, graphite on paper;
28 x 34 each:

1. *We Try Hard to Avoid Pain*
Collection Bo Alveryd, Kalinge, Sweden

2. *She Could Always Hide Behind Anger*
Courtesy Barbara Gladstone Gallery, New York

3. *She Kept Devising Means to Escape*
Courtesy Barbara Gladstone Gallery, New York

4. *Untitled*
Collection Nancy Hagin, New York

5. *She Tried Disposing of the Evidence*
Courtesy Barbara Gladstone Gallery, New York

6. *She Tried Pretending It Didn't Happen*
Private Collection, New York

7. *But She Can't Really Forget*
Private Collection, New York

8. *She Had to Confess "It Was Me"*
Collection John Breitweiser, Chicago

9. *Was There Shame?*
Private Collection, New York

3 paintings, oil on canvas:

10. *She Dreams of Her Name in Lights*
43½ x 49½
Collection Lynn and Jeffrey Slutsky, New York

11. *It Knows So Well How to Sing Her Dreams*
43½ x 49½
Courtesy Barbara Gladstone Gallery, New York

12. *She Wants to Belong to the Sky, Again* 1981
43½ x 61½
Collection Museum of Contemporary Art, Chicago,
Illinois Arts Council, Purchase Grant and
Museum Funds

13-58. Objects of mixed media, various
dimensions:
8 ceramic lamps
9 postcards
4 wooden plaques
4 ties
3 plates
3 fans
9 pairs of salt and pepper shakers
6 ashtrays
8 pencils in a can

Selected One Woman Exhibitions

1977
Nancy Lurie Gallery, Chicago
1979
Barbara Gladstone Gallery, New York
Fine Arts Center, University of Rhode Island,
Kingston
Nancy Lurie Gallery, Chicago
1980
Nancy Lurie Gallery, Chicago
Barbara Gladstone Gallery, New York
1981
Poisoned, Barbara Gladstone Gallery, New York
Okun-Thomas Gallery, St. Louis, Missouri
Incantations, Nancy Lurie Gallery, Chicago
1982
A Journey to Somewhere from Nowhere,
University of South Florida Art Galleries, Tampa

Selected Group Exhibitions

1973
74th Exhibition by Artists of Chicago and Vicinity,
The Art Institute of Chicago
1974
Artemisia Gallery, Chicago
Walter Kelly Gallery, Chicago
1977
Strong Works, Artemisia Gallery, Chicago
Personal Information, Nancy Lurie Gallery,
Chicago
1978
American Drawings: New Directions, University of
South Florida Art Galleries, Tampa
*Works on Paper, 77th Exhibition by Artists of
Chicago and Vicinity,* The Art Institute of Chicago
Lineup, The Drawing Center, New York
1979
Portraits, Aspen Center for the Visual Arts,
Colorado
Chicago Alternatives, Herron Gallery, Indiana
University, Indianapolis
Narrative Imagery, ARC Gallery, Chicago
1980
Renderings of the Modern Woman, University of
Hartford, Connecticut
Touch Me, N.A.M.E. Gallery, Chicago
1981
Whitney Biennial, Whitney Museum of
American Art, New York
Seven Artists, Museum of Contemporary Art,
Chicago
1982
New Drawings in America, Part I,
The Drawing Center, New York

Selected Bibliography

1978
Frueh, Joanna. "Hollis Sigler at Nancy Lurie," *Art
in America,* May/June, pp 121-122.
_____ . "The Personal Imperative:
Post-Imagist Art in Chicago," *The New Art
Examiner,* October, pp 4-5.
1979
Perrone, Jeff. "Reviews New York," *Artforum,*
Summer, p 71.
1980
Frueh, Joanna. "Hollis Sigler," *Arts Magazine,*
April, p 7.
1981
Casademont, Joan. "Reviews New York,"
Artforum, May, p 73.
Hess, Elizabeth. "Love Objects," *The Village Voice,*
March 11.
Westfall, S. "Hollis Sigler," *Arts Magazine,*
June, p 26.
1982
Schwartzman, Allan. "A Journey to Somewhere
from Nowhere," University of South Florida Art
Galleries, Tampa.
Zimmer, William. "Woman Under the Affluence,"
The Soho News, January 26, p 25.

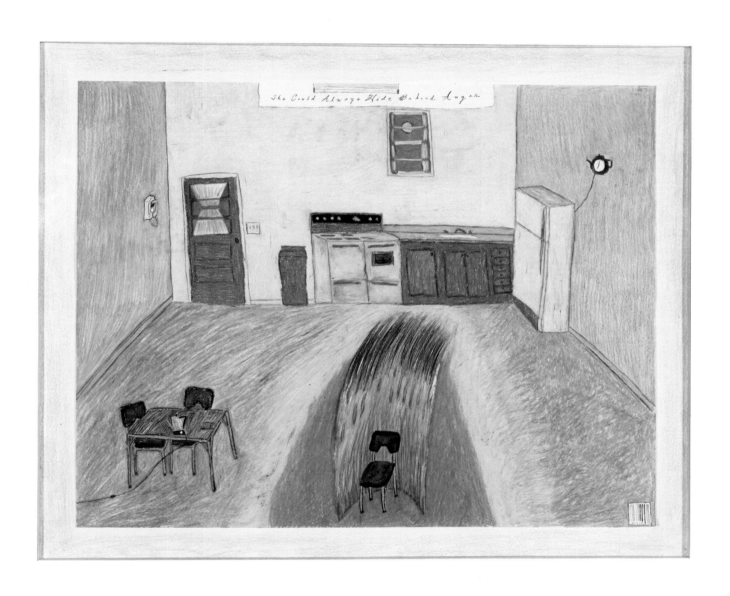

She Could Always Hide Behind Anger 1981
(Sigler checklist no 2)

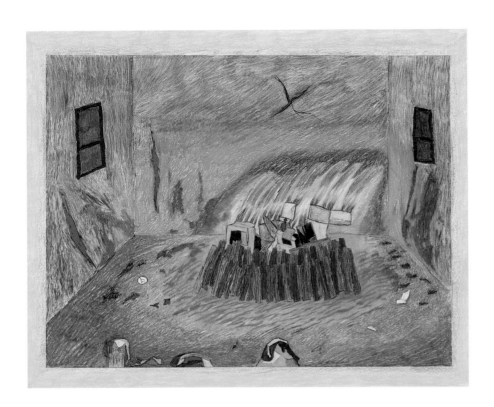

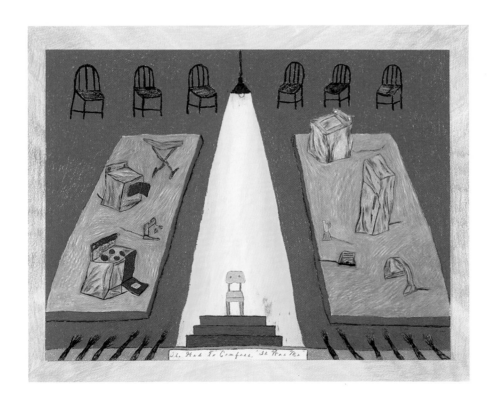

Untitled 1981
She Had to Confess "It Was Me" 1981
(Sigler checklist nos 4, 8)

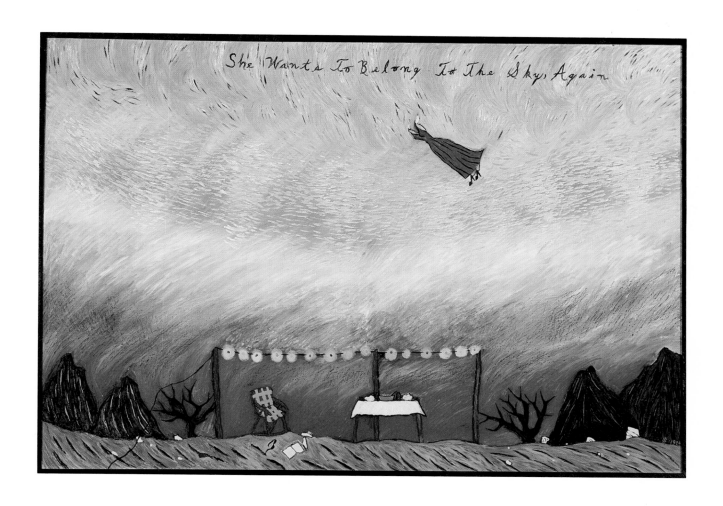

She Wants to Belong to the Sky, Again 1981
(Sigler checklist no 12)